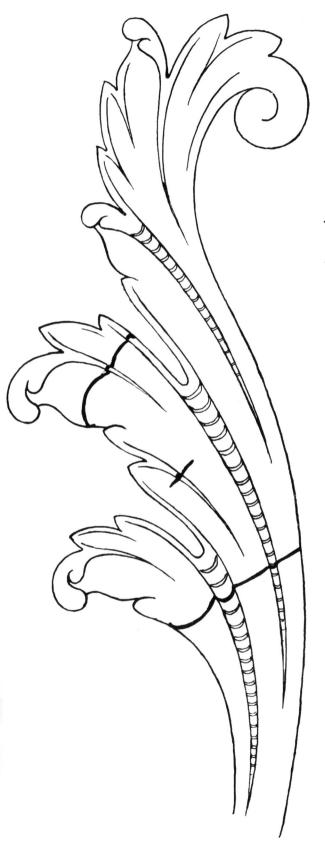

Classic
WROUGHT
IRONWORK
Patterns and Designs

Tunstall Small
and
Christopher Woodbridge

Dover Publications, Inc.
Mineola, New York

Bibliographical Note

This Dover edition, first published in 2005, is a new compilation of all 40 plates from *English Wrought Ironwork, Mediaeval and Early Renaissance,* published by The Architectural Press, London, and William Helburn Inc., New York, in 1931, and *English Wrought Ironwork of the Late 17th and Early 18th Centuries,* published by The Architectural Press and William Helburn Inc. in 1930. In each linear dimension, the plates in the Dover edition are about eighty percent of the size of those in the original volumes.

DOVER *Pictorial Archive* SERIES

Library of Congress Cataloging-in-Publication Data

Small, Tunstall.
 Classic wrought ironwork : patterns and designs / Tunstall Small and Christopher Woodbridge.— Dover ed.
 p. cm. — (Dover pictorial archive series)
 "New compilation of all 40 plates from 'English Wrought Ironwork, Mediaeval and Early Renaissance,' published by The Architectural Press, London, and William Helburn Inc., New York, in 1931, and 'English Wrought Ironwork of the Late 17th and Early 18th Centuries,' published by The Architectural Press and William Helburn Inc. in 1930"—T.p. verso.
 ISBN 0-486-44364-7 (pbk.)
 1. Wrought-iron—England. 2. Decoration and ornament—England. I. Woodbridge, Christopher. II. Title. III. Series.

NK8243.A1S63 2005
739.4'0942'09032—dc22

 2005048478

Manufactured in the United States of America
Dover Publications, Inc., 31 East 2nd Street, Mineola, N.Y. 11501

FIRST PREFACE

(English Wrought Ironwork, Mediaeval and Early Renaissance)

This portfolio is essentially a companion volume to our previous publication *English Wrought Ironwork of the Late Seventeenth and Early Eighteenth Centuries,*[1] and, like its predecessor, is the outcome of a feeling that the works on Ironwork already published, consisting almost entirely of photographs or small-scale drawings, leave the reader more or less ignorant of true shapes and dimensions and the constructional methods employed. In this portfolio all the details illustrated are drawn to full size,[2] and in the majority of cases a small-scale measured drawing of the subject from which the details are taken has been included in order to show their position, relationship and general arrangement.

In selecting examples for illustration, we have made a point of including a large proportion of subjects which, in our opinion, offer suggestions for modern domestic work, and for this reason we have given preference to the more simple type of design and excluded the more elaborate ecclesiastical work.

We are hopeful that the work will prove a valuable source of inspiration and suggestion to designers of Ironwork—even to those with pronounced modern tendencies—in so far as it reveals the processes of work and thought employed by the early masters of the craft.

An indication of the approximate dates of the examples illustrated will be found in the List of Plates.

We acknowledge with grateful thanks the assistance which has been given us by the authorities of the Victoria and Albert Museum and the Geffrye Museum, and by many others who have kindly given us permission to examine and reproduce examples of ironwork under their care.

<div align="right">
T. S.

C. W.
</div>

[1] Included as pages 21–40 in this Dover edition.

[2] In the Dover edition, each linear dimension is about eighty percent of the original size.

SECOND PREFACE

(English Wrought Ironwork of the Late 17th and Early 18th Centuries)

This portfolio of late 17th and early 18th Century Ironwork may be regarded as a companion work to *Houses of the Wren and Early Georgian Periods* by the same authors, and the production has been the outcome of a feeling that the works on Ironwork now published, consisting almost entirely of photographs, leave one more or less ignorant as to true shapes and dimensions and the constructional methods employed.

Throughout the work the authors have been careful to embody this vital information in their delineations, in order that the examples selected for illustration may reveal the processes of thought by which the original craftsmen attained such mastery of design.

Every effort has been made to show representative types of ironwork detail. These have been selected from works by such famous smiths as Jean Tijou, Robert Bakewell, Thomas Robinson, William Edney, and Warren, and include Vases, Finials, Spikes, Dogbars, repoussé ornaments such as Rosettes, grotesque Masks, Urns, Fiddle Scrolls, Eagle's Heads, types of Leafwork, etc., taken from Gates and Railings, Ramps, Screens, Staircases, Brackets, and the like.

As a means of indicating the position, relationship and general arrangement of the Details, a small measured drawing with scale attached has been included in most instances.

All the details are full-size with the exception of Sheet 33, Garden Screen, Hampton Court Palace, which on account of its size has been drawn to half scale.

The authors acknowledge with grateful thanks the assistance which has been given them by the officials of public bodies and owners of private houses, who have kindly given them permission to examine and reproduce examples of iron-work under their care.

T. S.
C. W.

LIST OF PLATES

HINGES
External

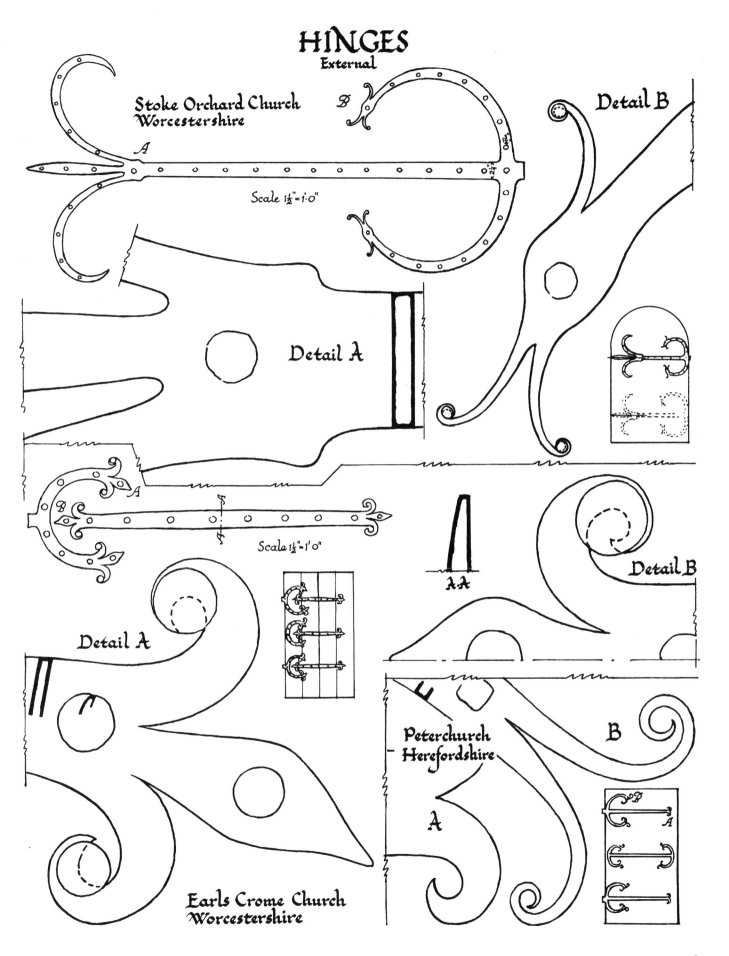

Stoke Orchard Church
Worcestershire

B

Detail B

A

Scale 1½"=1'0"

Detail A

Detail B

Detail A

Scale 1½"=1'0"

λλ

Peterchurch
Herefordshire

B

A

Earls Crome Church
Worcestershire

1

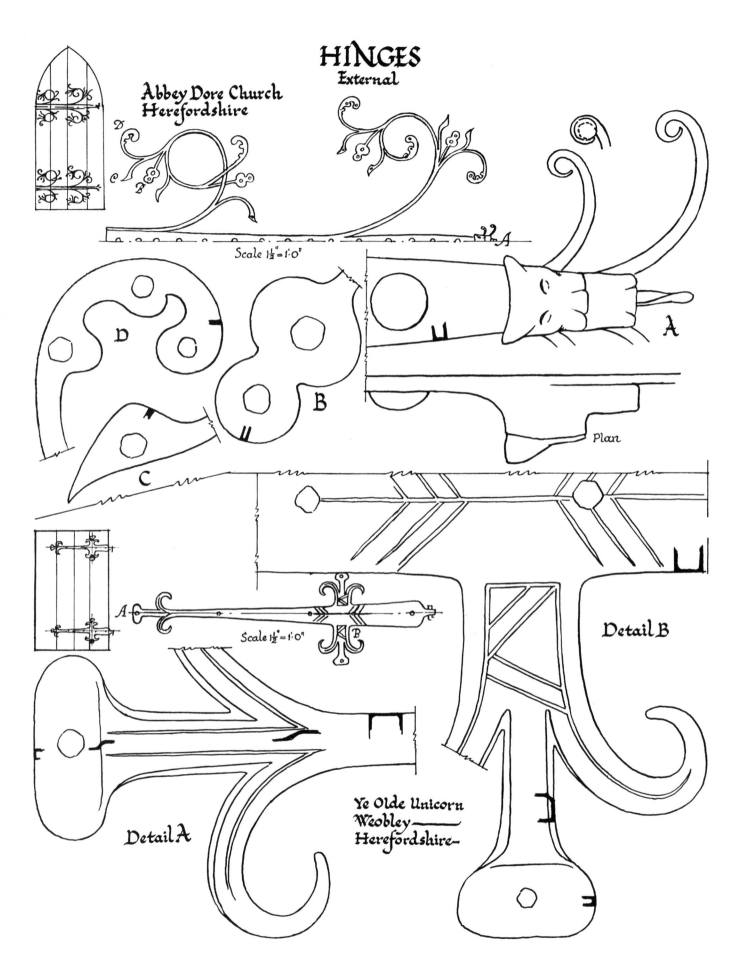

HINGES
External

Abbey Dore Church
Herefordshire

Scale 1½" = 1'·0"

D

B

C

A

Plan

A

B

Scale 1½" = 1'·0"

Detail B

Detail A

Ye Olde Unicorn
Weobley —
Herefordshire—

HINGES

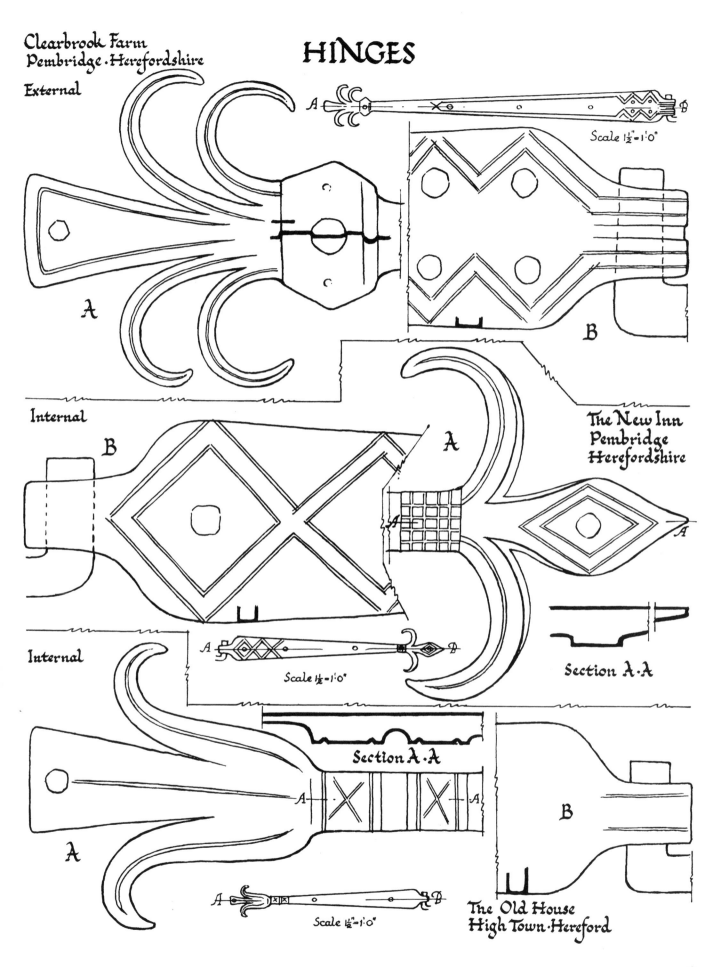

Clearbrook Farm
Pembridge · Herefordshire

External

Scale 1½" = 1'·0"

A

B

Internal

B

A

The New Inn
Pembridge
Herefordshire

A

A

Section A·A

Internal

A

B

Scale 1½" = 1'·0"

A

Section A·A

A

A

A

B

Scale 1½" = 1'·0"

The Old House
High Town · Hereford

3

HINGES

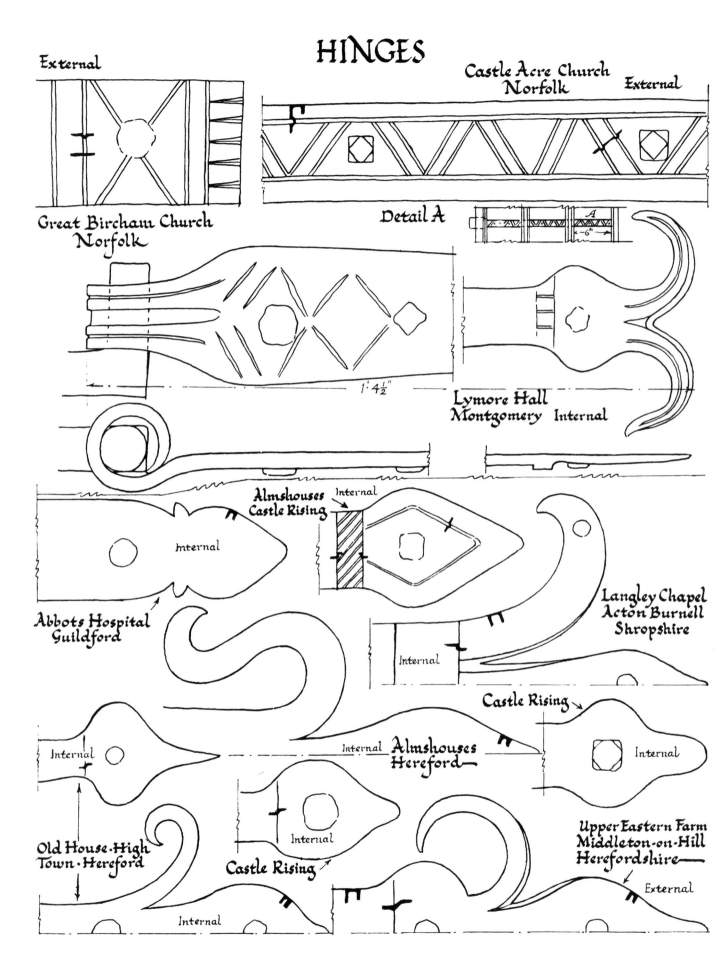

External

Castle Acre Church
Norfolk External

Great Bircham Church
Norfolk

Detail A

Lymore Hall
Montgomery Internal

Almshouses
Castle Rising Internal

Internal

Abbots Hospital
Guildford

Internal

Langley Chapel
Acton Burnell
Shropshire

Castle Rising

Internal

Internal Almshouses
Hereford

Internal

Old House·High
Town·Hereford

Internal

Castle Rising

Upper Eastern Farm
Middleton-on-Hill
Herefordshire

External

Internal

$1'\,4\frac{1}{2}''$

HINGES
Internal

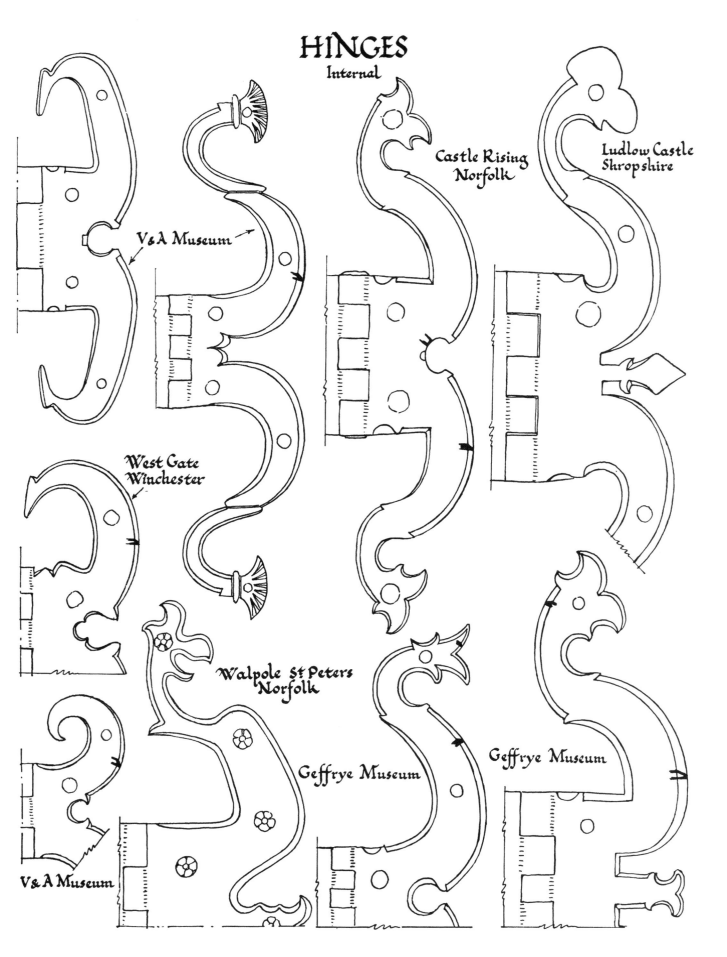

Castle Rising
Norfolk

Ludlow Castle
Shropshire

V & A Museum

West Gate
Winchester

Walpole St Peters
Norfolk

V & A Museum

Geffrye Museum

Geffrye Museum

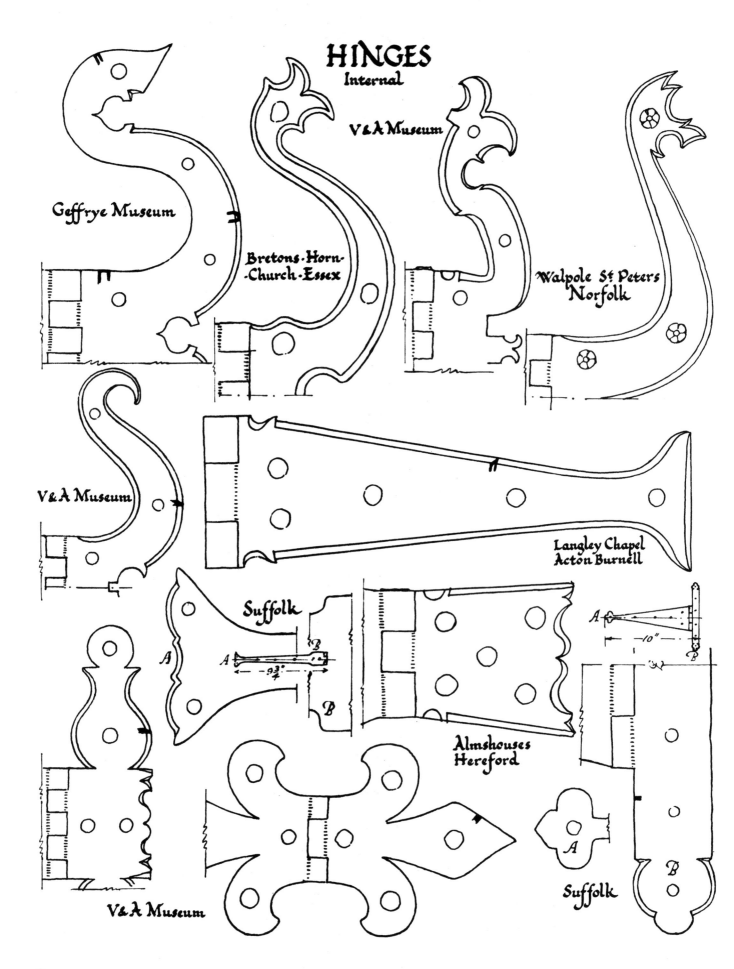

HINGES
Internal

V & A Museum

Geffrye Museum

Bretons · Horn-
· Church · Essex

Walpole St Peters
Norfolk

V & A Museum

Langley Chapel
Acton Burnell

Suffolk

Almshouses
Hereford

V & A Museum

Suffolk

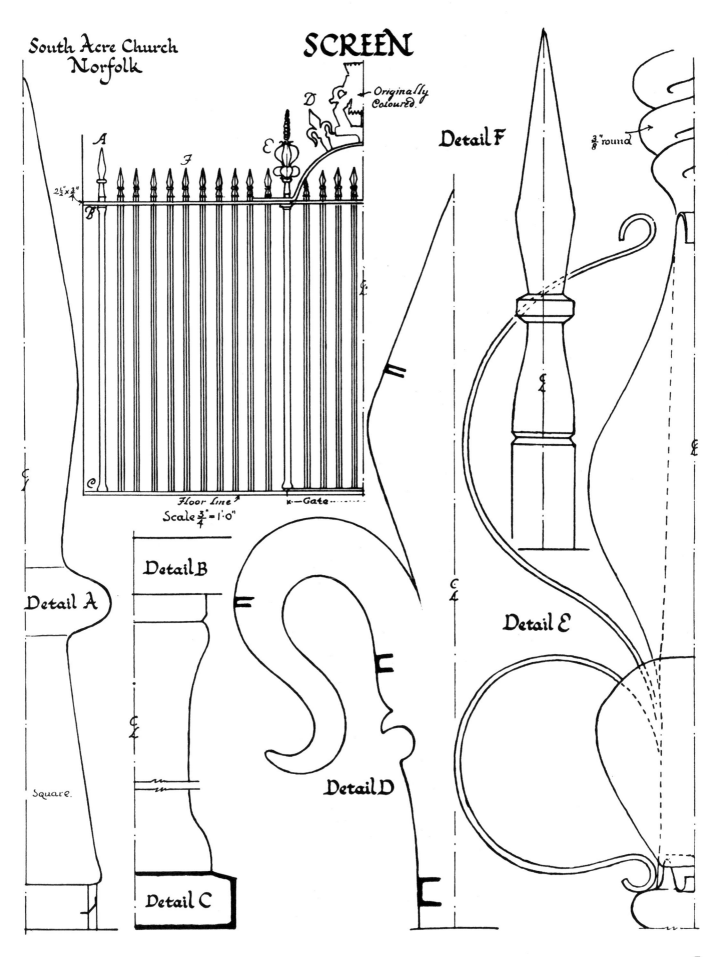

South Acre Church
Norfolk

SCREEN

Originally
Coloured.

$2\frac{1}{2}" \times \frac{3}{4}"$

Detail F

$\frac{3}{8}"$ round

Floor Line
Scale $\frac{3}{4}" = 1\cdot0"$

x—Gate

Detail A

Detail B

Square.

Detail C

Detail D

Detail E

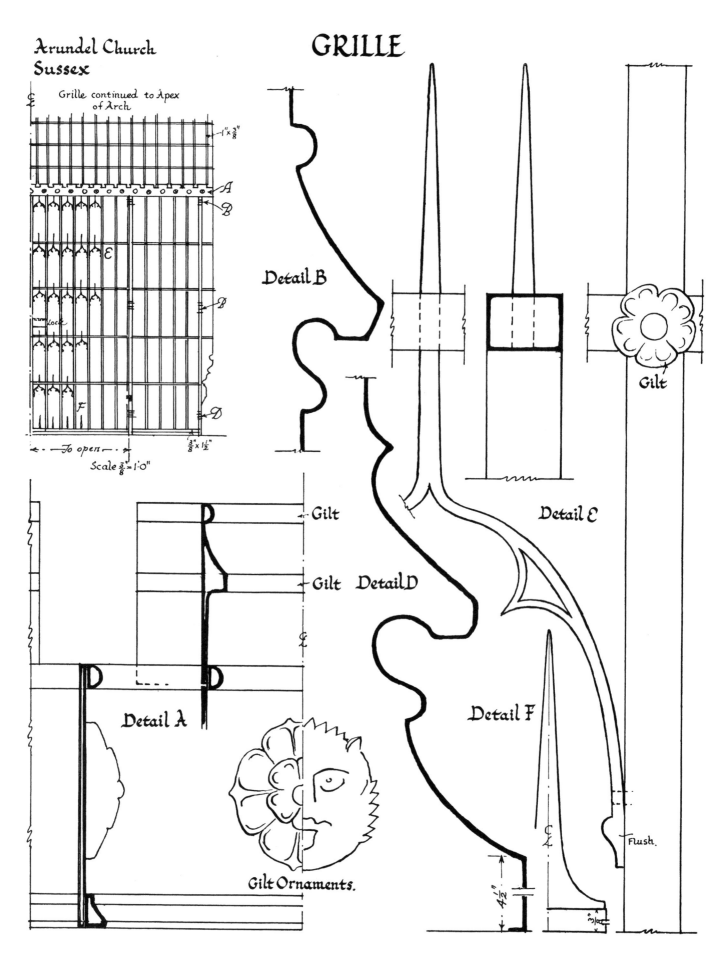

Arundel Church
Sussex

Grille continued to Apex
of Arch

1"×³⁄₈"

A

B

E

B

Lock

F

D

³⁄₈"×1½"

To open

Scale ³⁄₈"=1'0"

Detail B

Gilt

Detail E

Gilt

Gilt

Detail D

Detail A

Detail F

Gilt Ornaments.

4½"

Flush.

³⁄₄"

8

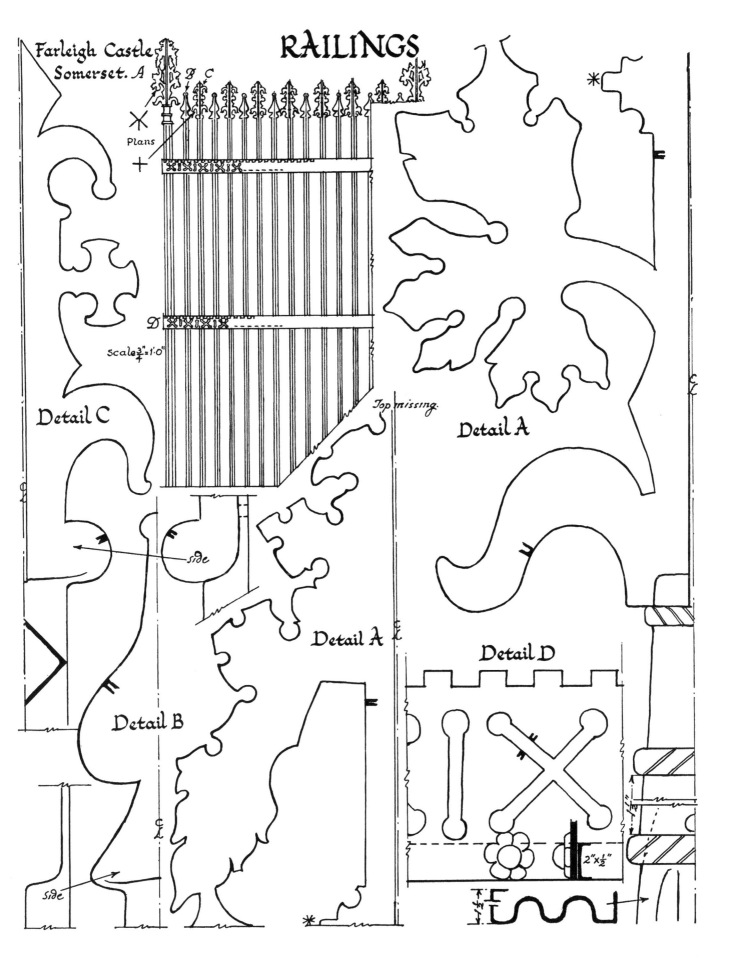

RAILINGS

Farleigh Castle
Somerset. A

Plans

Detail C

Detail A

Top missing.

side

Detail A

Detail B

Detail D

side

Scale $\frac{3}{4}$"=1'0"

2"×$\frac{1}{2}$"

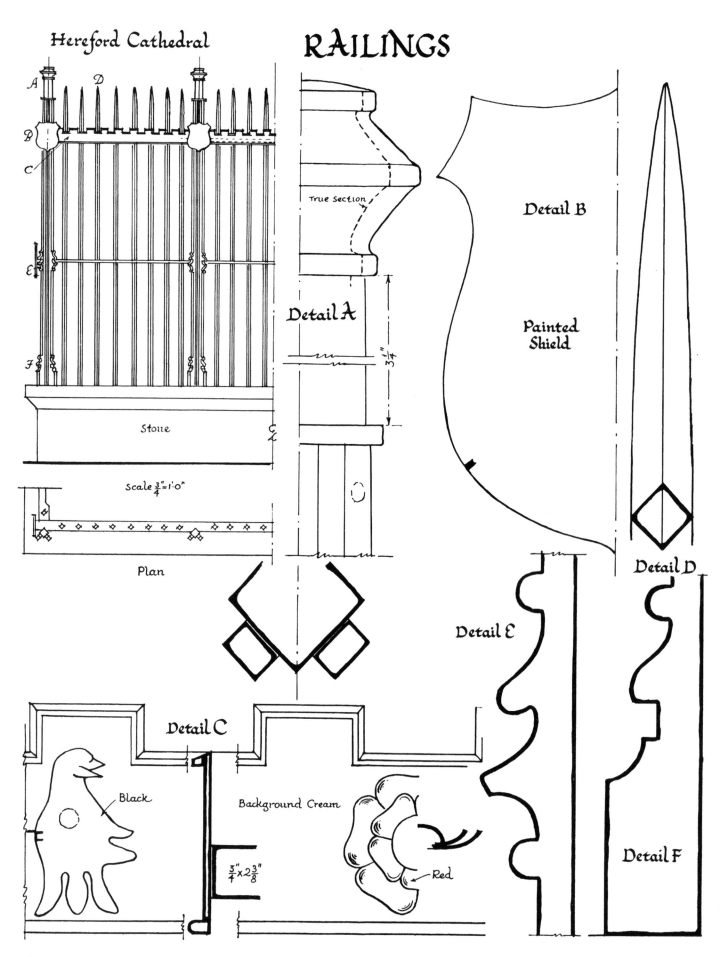

Hereford Cathedral

RAILINGS

A
B
C
D
E
F

Stone

Scale 3/4" = 1'-0"

Plan

True Section

Detail A

3 1/4"

Detail B

Painted
Shield

Detail D

Detail E

Detail C

Black

Background Cream

3/4" x 2 3/8"

Red

Detail F

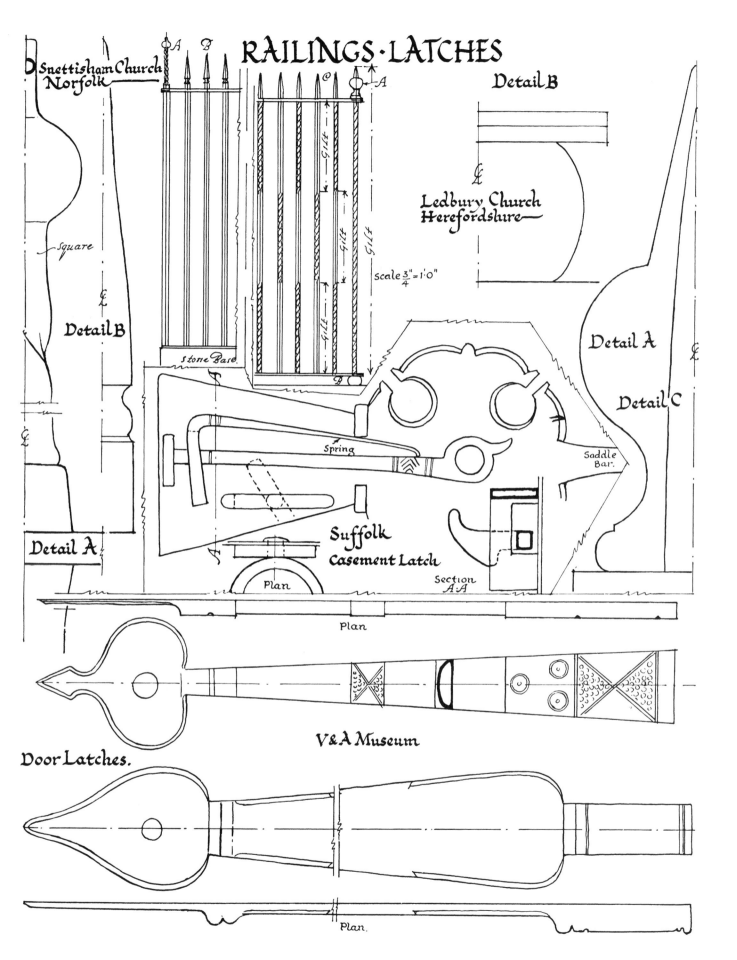

RAILINGS·LATCHES

Snettisham Church Norfolk

Detail B

Detail A

A B

C A

Square

Gilt

Gilt

Gilt

Gilt

Gilt

Scale ¾" = 1'·0"

Stone Base

Spring

Suffolk Casement Latch

Plan

Plan

Section A·A

Detail B

Ledbury Church Herefordshire

Detail A

Detail C

Saddle Bar.

Door Latches.

V & A Museum

Plan

Plan.

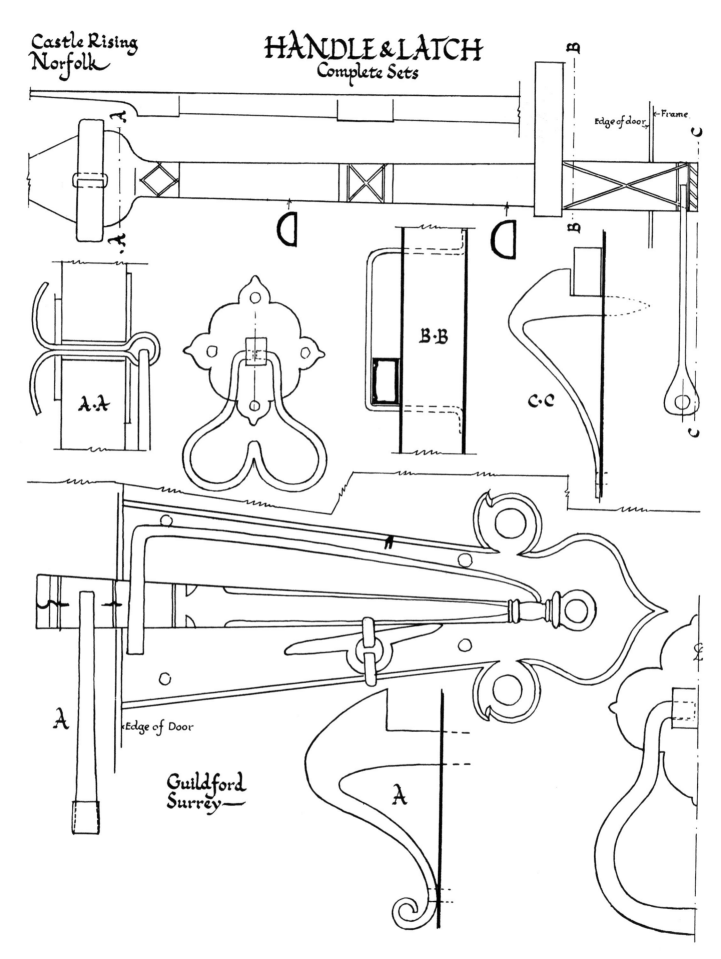

Castle Rising
Norfolk

HANDLE & LATCH
Complete Sets

Edge of door → ← Frame

A·A

B·B

C·C

Edge of Door

A

Guildford
Surrey—

A

CASEMENT FASTENER

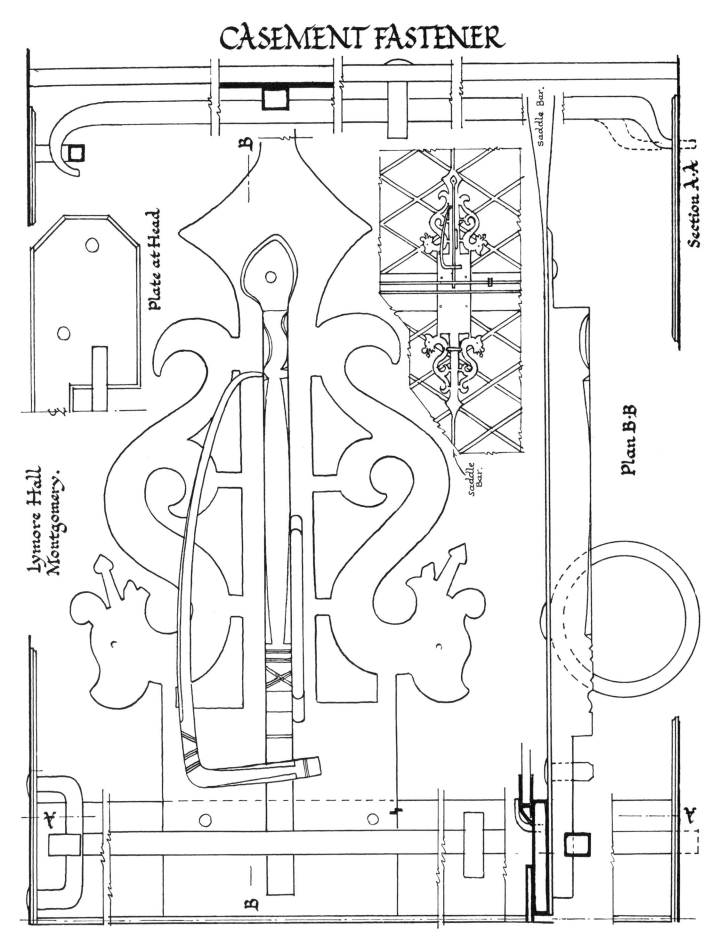

Lymore Hall
Montgomery.

Plate at Head

saddle Bar.

saddle Bar.

Plan B·B

Section A·A

CASEMENT FASTENER·PULLS·&·DOOR BOLTS

Lymore Hall
Montgomery.

Door Bolt

Frame.

Plan

Casement Pulls

Suffolk

Suffolk

Plan →

Plan.

Similar Bolt at top
of door but with long
arm as dotted.

10"

Lymore Hall
Montgomery

Door Bolt

℄
Plan.

Suffolk

Casement Fastener

Floor Line.

DROP HANDLES

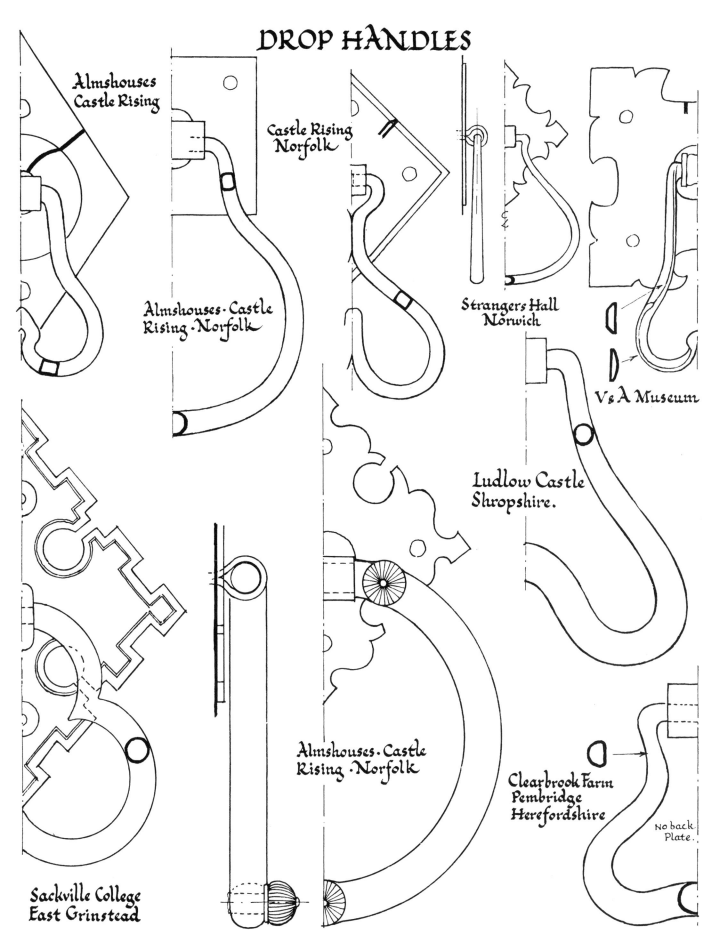

Almshouses Castle Rising

Castle Rising Norfolk

Almshouses · Castle Rising · Norfolk

Strangers Hall Norwich

V & A Museum

Ludlow Castle Shropshire.

Sackville College East Grinstead

Almshouses · Castle Rising · Norfolk

Clearbrook Farm Pembridge Herefordshire

No back Plate.

DROP HANDLES

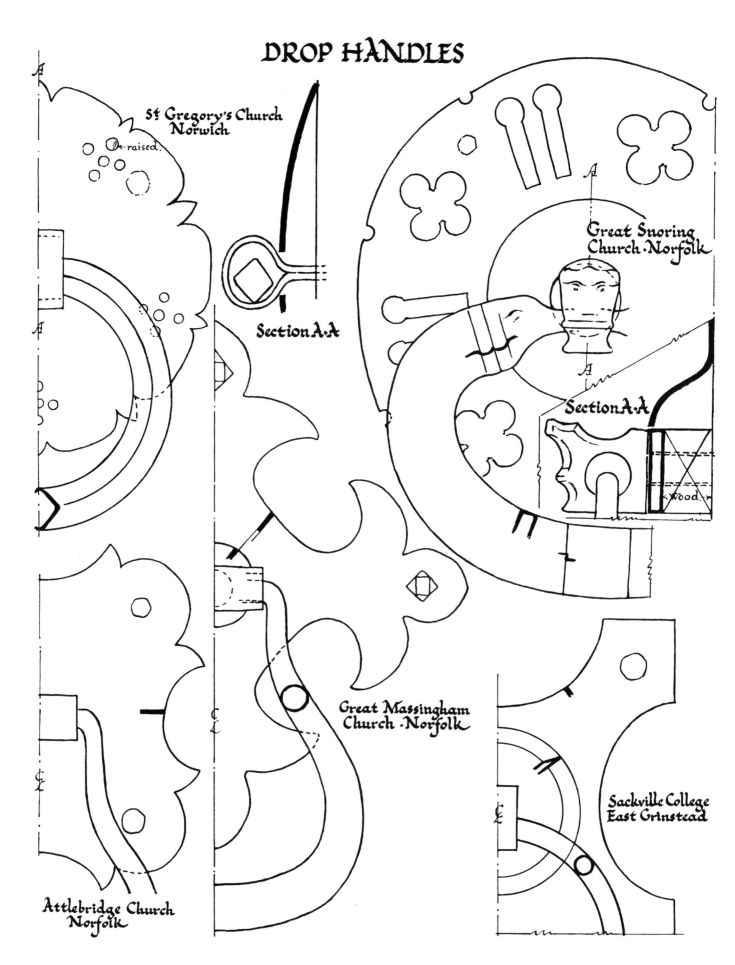

St Gregory's Church
Norwich

X-raised.

Section A·A

Great Snoring
Church · Norfolk

Section A·A

Wood

Great Massingham
Church · Norfolk

Attlebridge Church
Norfolk

Sackville College
East Grinstead

DROP HANDLES

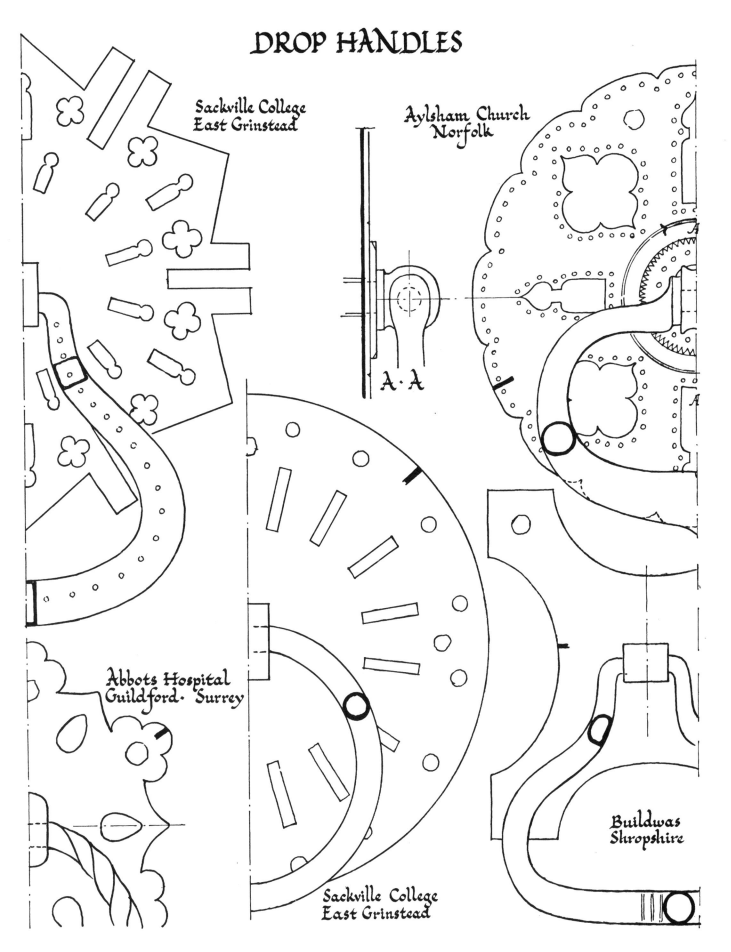

Sackville College
East Grinstead

Aylsham Church
Norfolk

A·A

Abbots Hospital
Guildford· Surrey

Sackville College
East Grinstead

Buildwas
Shropshire

HANDLES

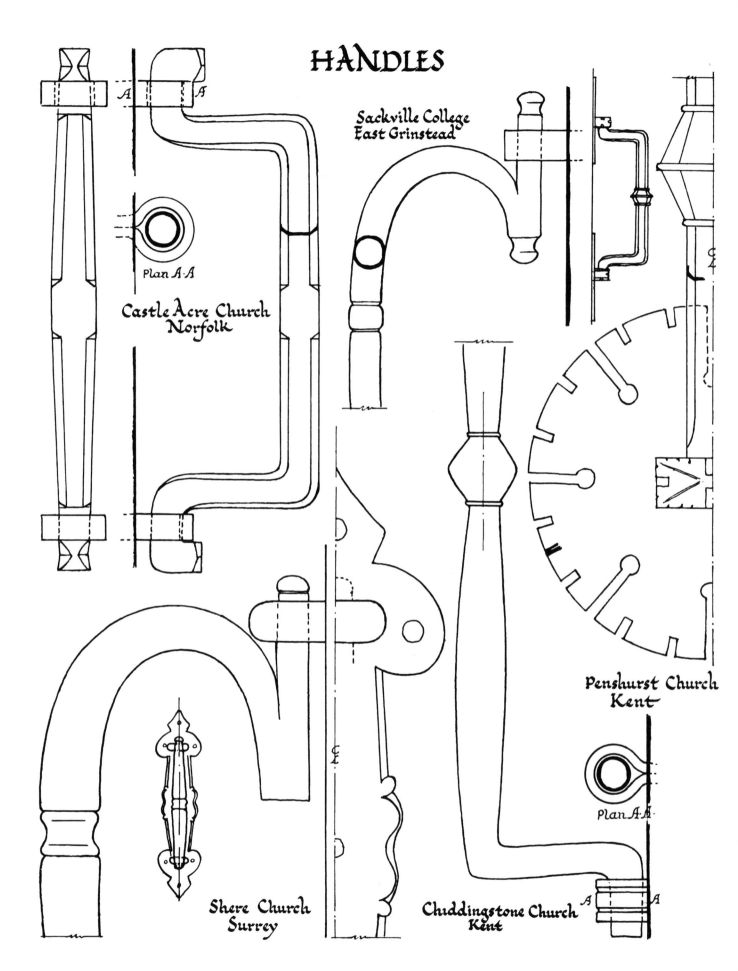

Sackville College
East Grinstead

Plan A·A

Castle Acre Church
Norfolk

Penshurst Church
Kent

Plan A·A

Shere Church
Surrey

Chiddingstone Church
Kent

KEY ESCUTCHEONS

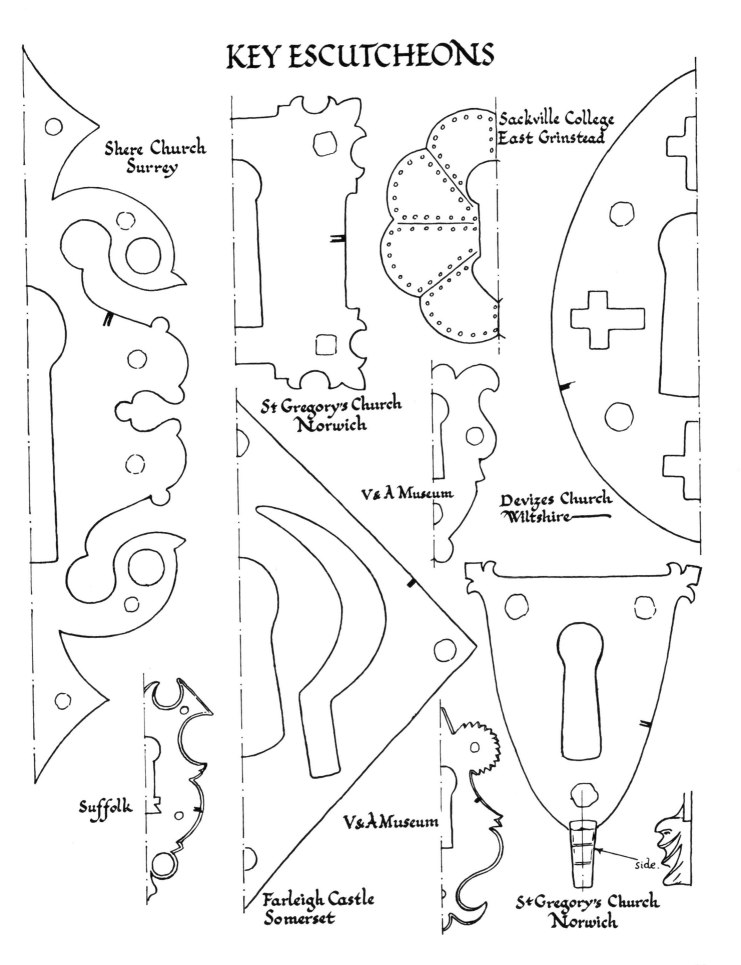

Shere Church
Surrey

St Gregory's Church
Norwich

Sackville College
East Grinstead

V & A Museum

Devizes Church
Wiltshire

Suffolk

V & A Museum

Farleigh Castle
Somerset

side.

St Gregory's Church
Norwich

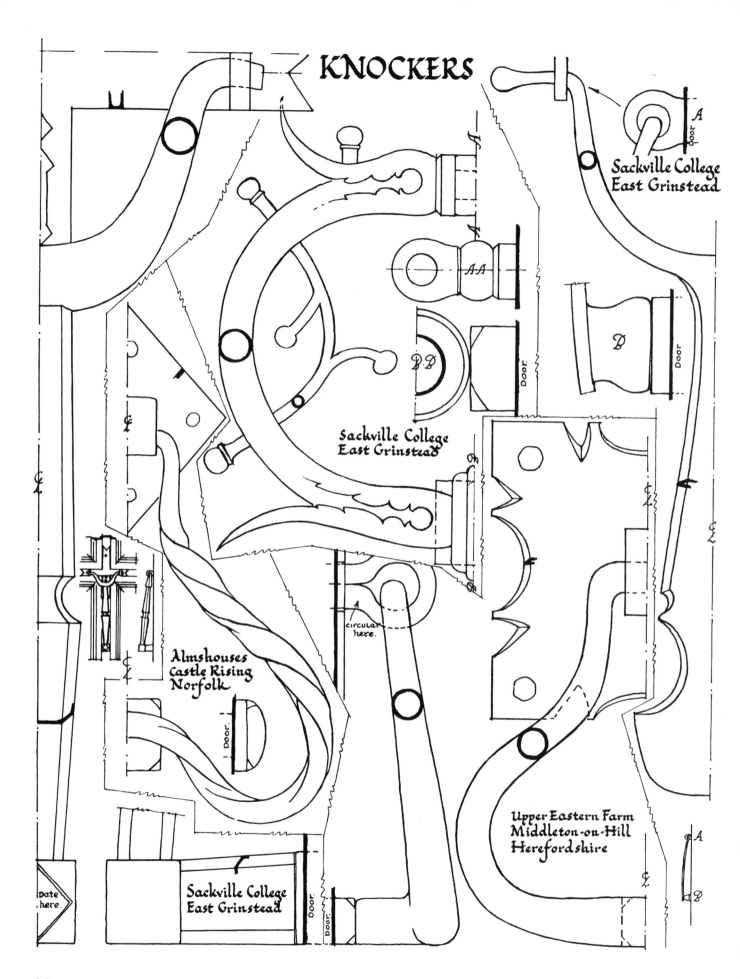

KNOCKERS

Sackville College
East Grinstead

Sackville College
East Grinstead

Almshouses
Castle Rising
Norfolk

Upper Eastern Farm
Middleton-on-Hill
Herefordshire

Sackville College
East Grinstead

circular
here.

Door.

Door.

Door.

Door.

Door.

Date
here.

20

Gate

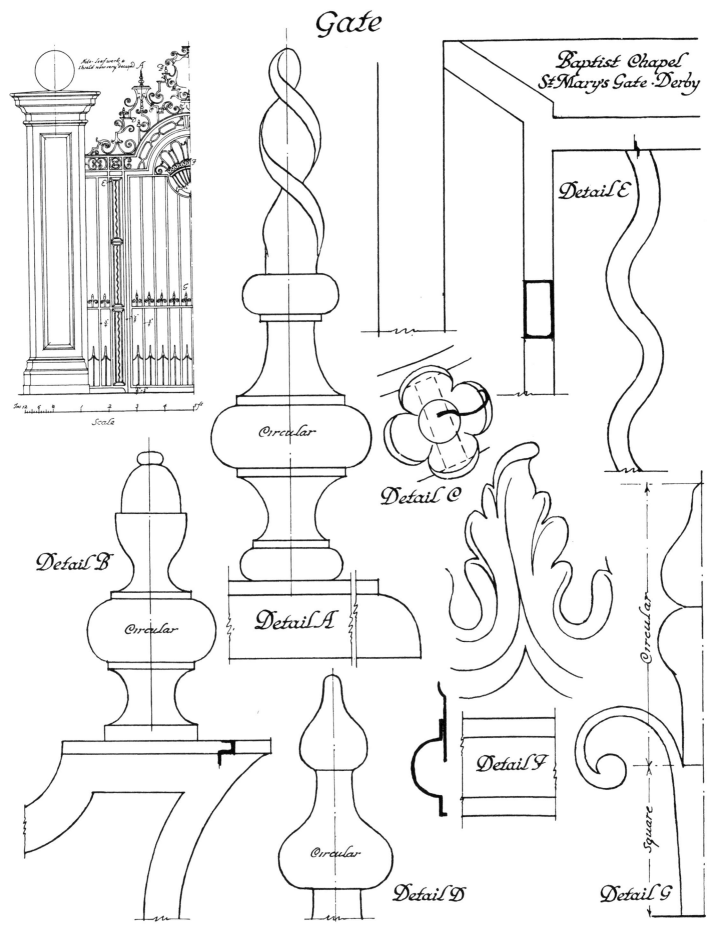

Note:- leaf work &
shield now very decayed. A

Scale

Baptist Chapel
St Mary's Gate · Derby

Detail E

Circular

Detail C

Detail B

Circular

Circular

Detail A

Detail F

Circular

Square

Detail D

Circular

Detail G

21

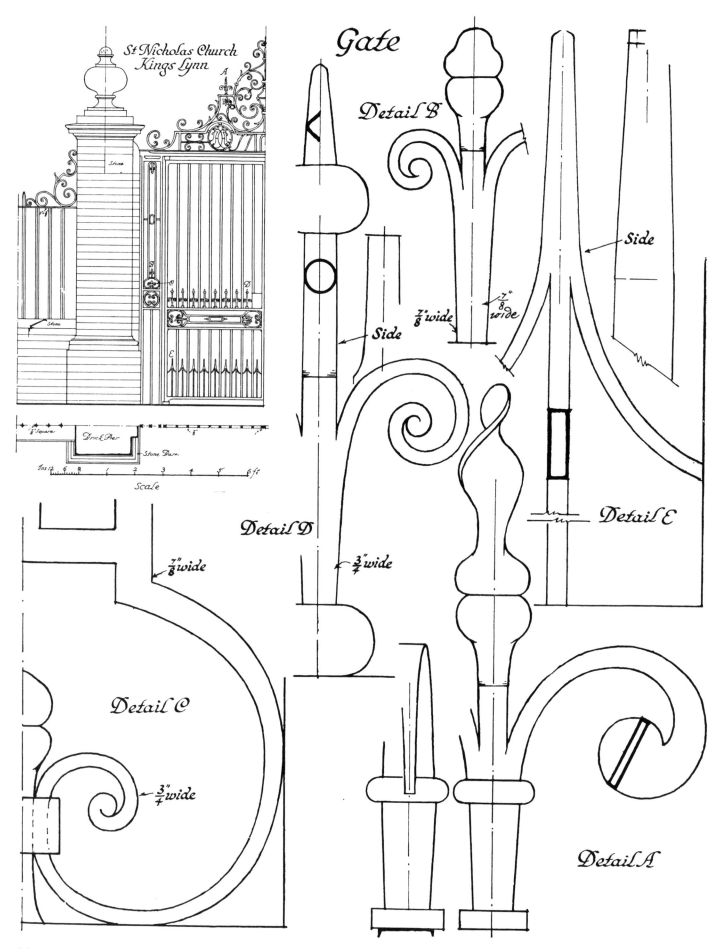

Gate

St Nicholas Church
Kings Lynn

Stone

Stone

⅛ *Square*

Brick Pier

Stone Base

Ins 12 6 3 1 2 3 4 5 6 ft

Scale

Detail B

Side

⅞" wide

⅞" wide

Side

Detail E

Detail D

¾" wide

Detail C

⅞" wide

¾" wide

Detail A

22

Gate & Railings

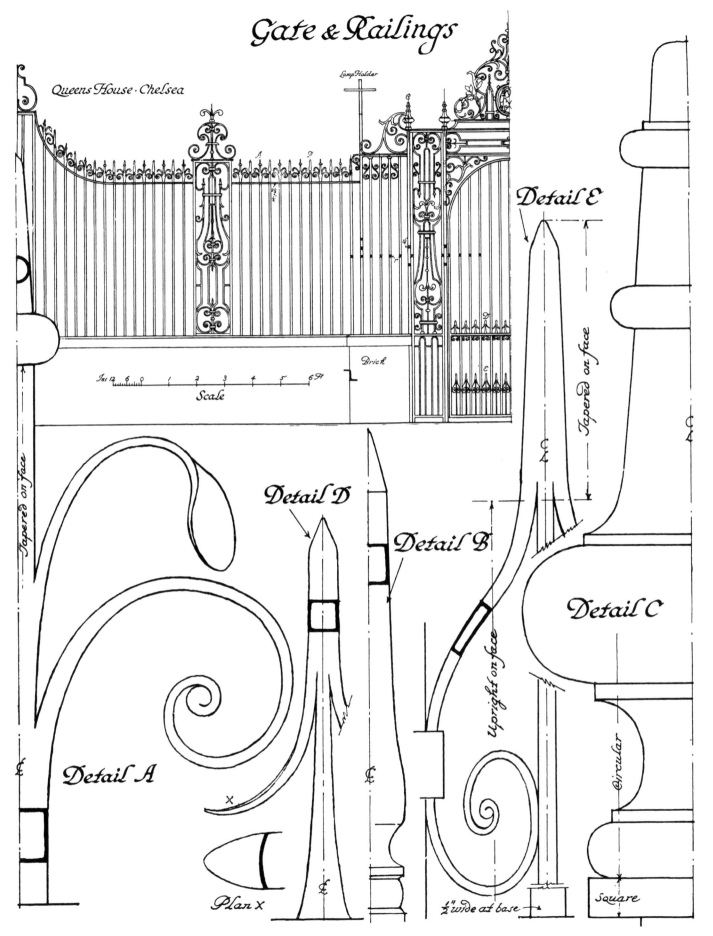

Queens House · Chelsea

LampHolder

Detail E

Brick

Tapered on face

Ins 12 6 3 0 1 2 3 4 5 6 *Ft*

Scale

Detail D

Detail B

Tapered on face

Detail C

Tapered on face

Upright on face

Detail A

Circular

Plan X

½" wide at base

Square

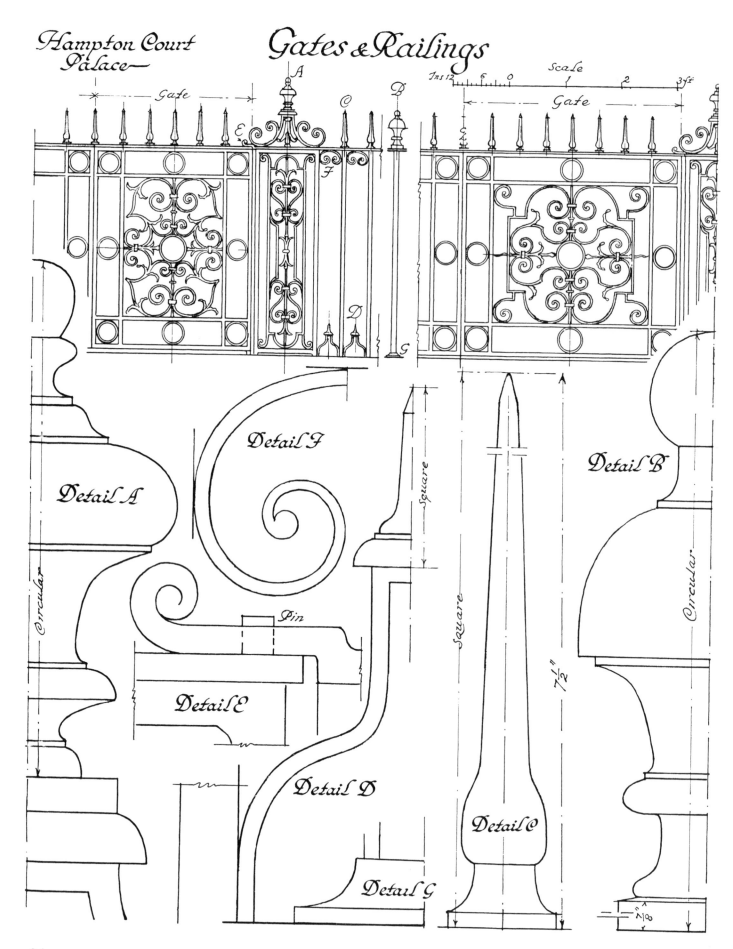

Hampton Court
Palace—

Gates & Railings

Scale

Ins 12 6 0 1 2 3 ft

Gate

Gate

A

C

D

E

F

D

G

Detail F

Detail A

Square

Detail B

Circular

Pin

Detail E

Circular

Detail D

Square

7½"

Detail G

Detail C

24

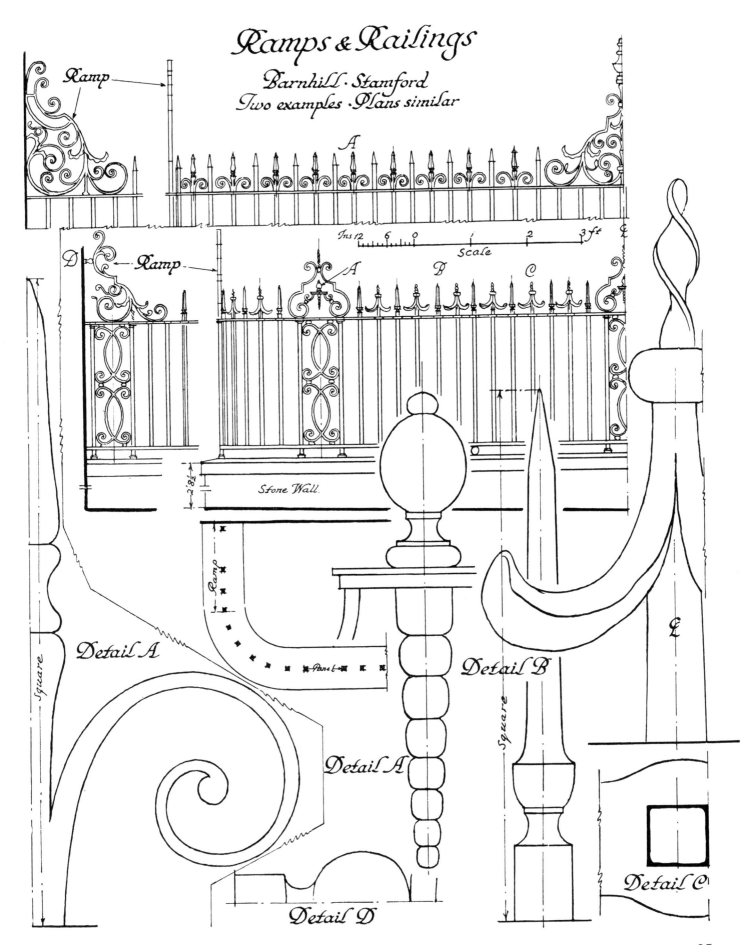

Ramps & Railings

Barnhill · Stamford
Two examples · Plans similar

Ramp

A

Ins 12 6 0 1 2 3 ft
Scale

D *Ramp* *A* *B* *C*

Stone Wall.

2'8½"

Ramp

Panel

Square

Detail A

Detail A

Detail B

Square

Detail D

Detail C

25

Ramp & Railings

Guild Hall·Worcester

Ins 12 6 0 1 2 3 4 5 ft

Scale

Detail A

Circular

Square

Detail E

Detail D

Detail C

$2\frac{1}{4}" \times \frac{1}{2}"$

$\frac{7}{8}"$

Square

Detail B

26

Railings

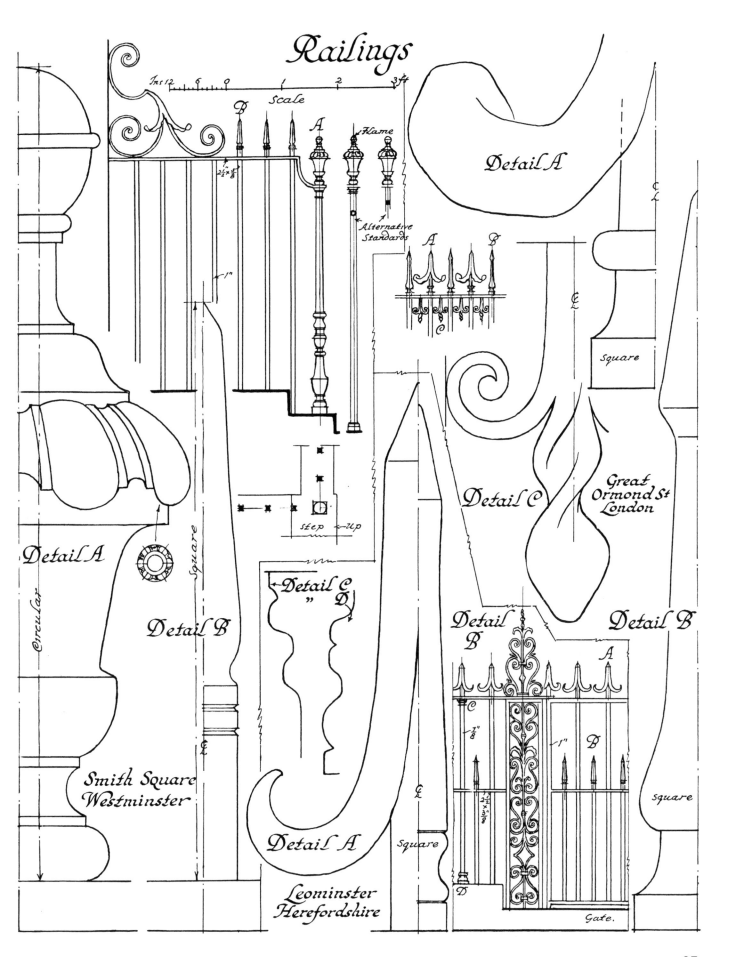

Scale

Ins 12 6 9 1 2 3 4

Detail A

$2\frac{1}{4}" \times \frac{5}{8}"$

1"

\mathcal{B} A Flame

Alternative Standards

A \mathcal{B}

C

Detail A

Circular

Square

Detail B

Smith Square
Westminster

step Up

Detail C
" D

Detail A

Leominster
Herefordshire

Square

Detail C

Great
Ormond St
London

Detail B
\mathcal{B}

C

$\frac{7}{8}"$

$\frac{2\frac{1}{4}}{\times \frac{3}{8}}"$

D

A

1"

\mathcal{D}

square

Gate.

Detail B

Square

27

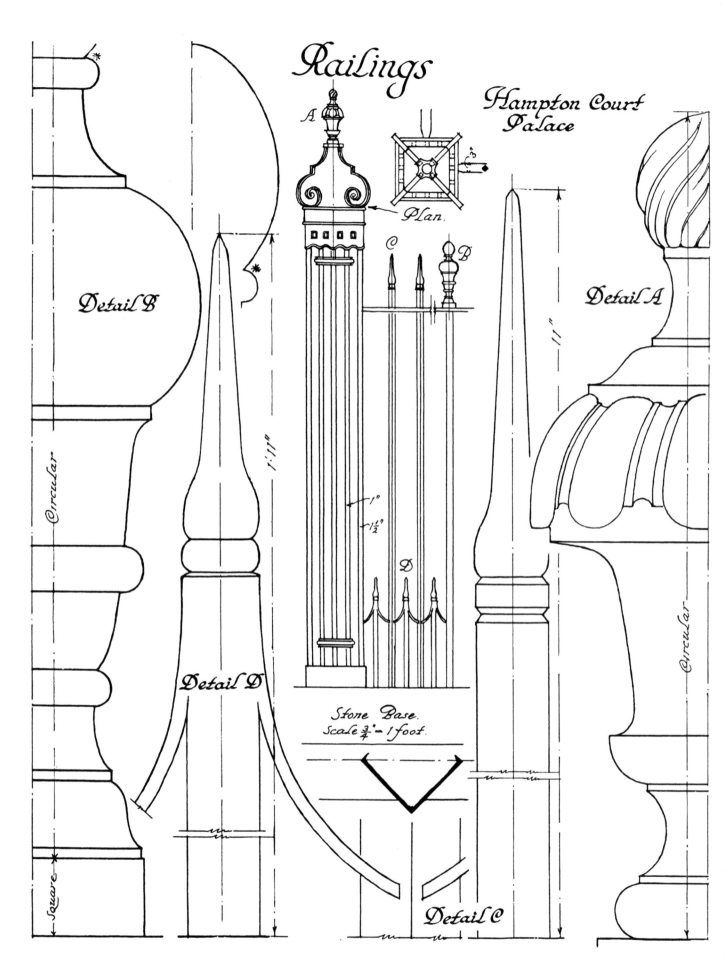

Railings

Hampton Court Palace

Detail B

Circular

Square

Detail D

A

Plan.

C

B

D

Stone Base.
Scale ¾" = 1 foot.

Detail C

Detail A

Circular

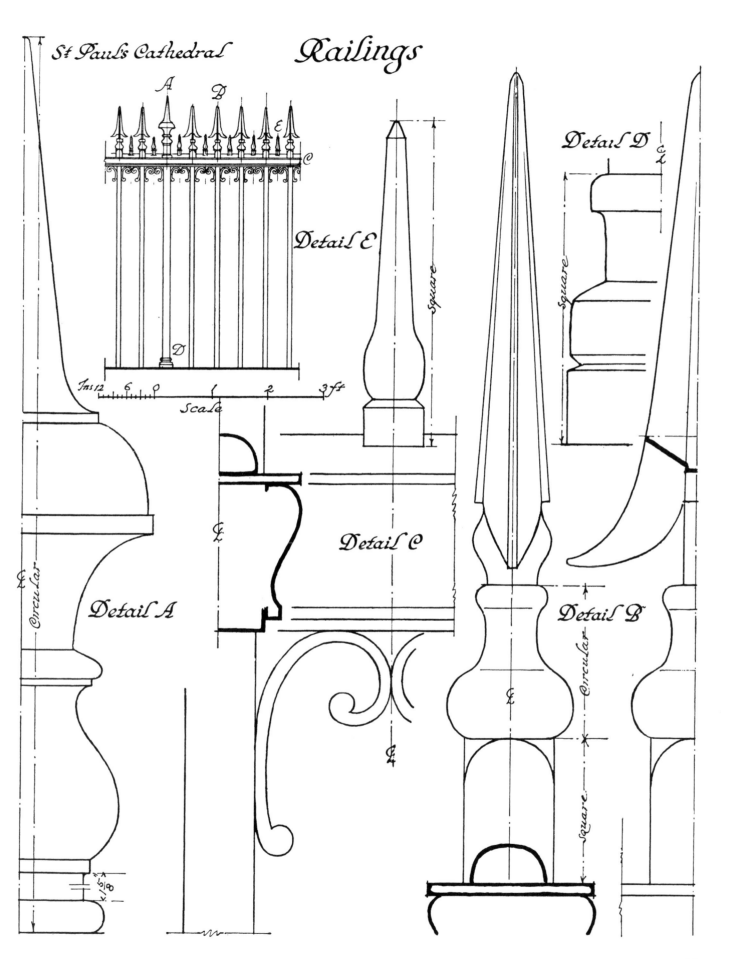

St Pauls Cathedral — *Railings*

A

D

E

C

D

Detail E

Square

Detail D

Square

Scale — Ins 12 6 0 1 2 3 ft

Detail C

Circular

Detail A

5/8"

Circular

Detail B

Square

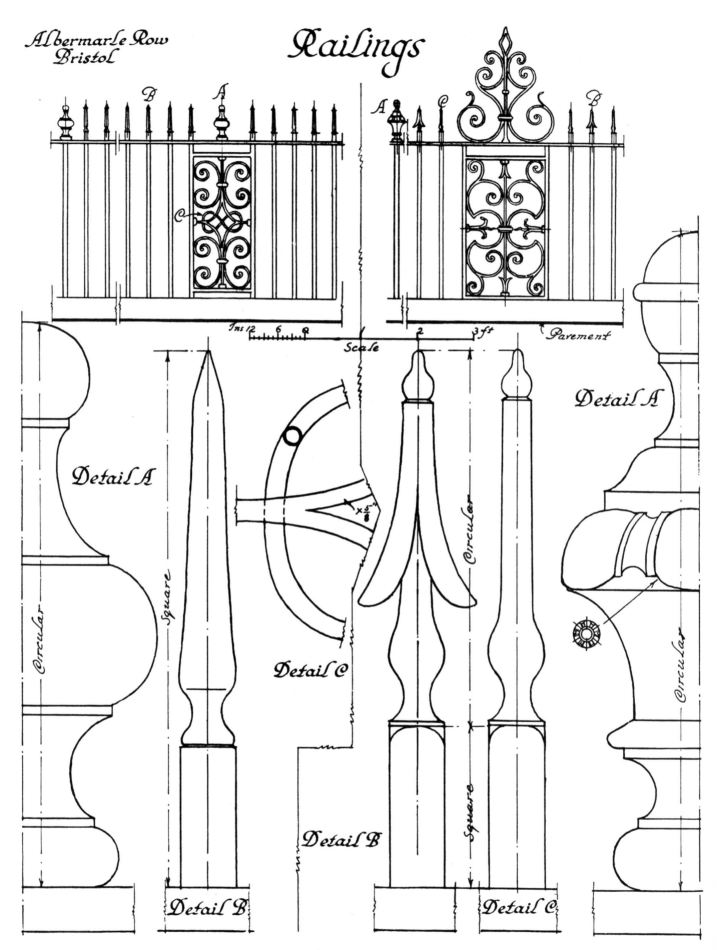

Albermarle Row
Bristol

B A

A C B

Ins 12 6 0 2 3 ft
Scale

Pavement

Detail A

Circular Square

Detail C

x 5/8"

Circular Square Circular

Detail A

Detail B

Detail B Detail C

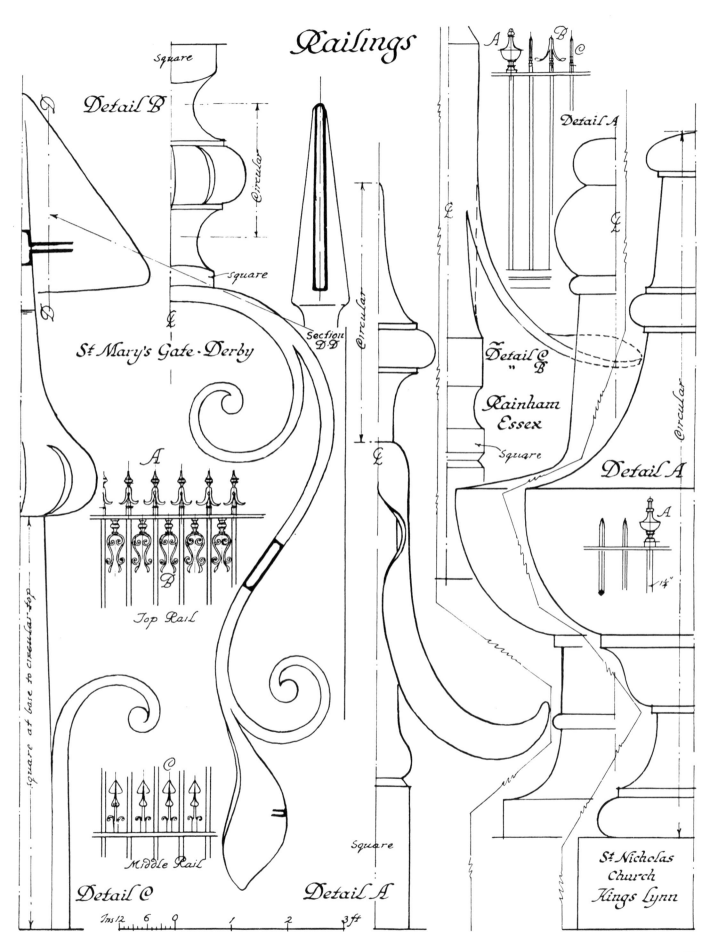

Railings

Detail B

Square

Circular

square

Section D·D

St Mary's Gate · Derby

Top Rail

Middle Rail

Detail C

Detail A

A

B

C

Detail A

Detail C
"
B

Rainham
Essex

Square

Detail A

A

¼"

St. Nicholas
Church
Kings Lynn

square at base to circular-top

Circular

Circular

Square

Ins 12 6 0 1 2 3 ft

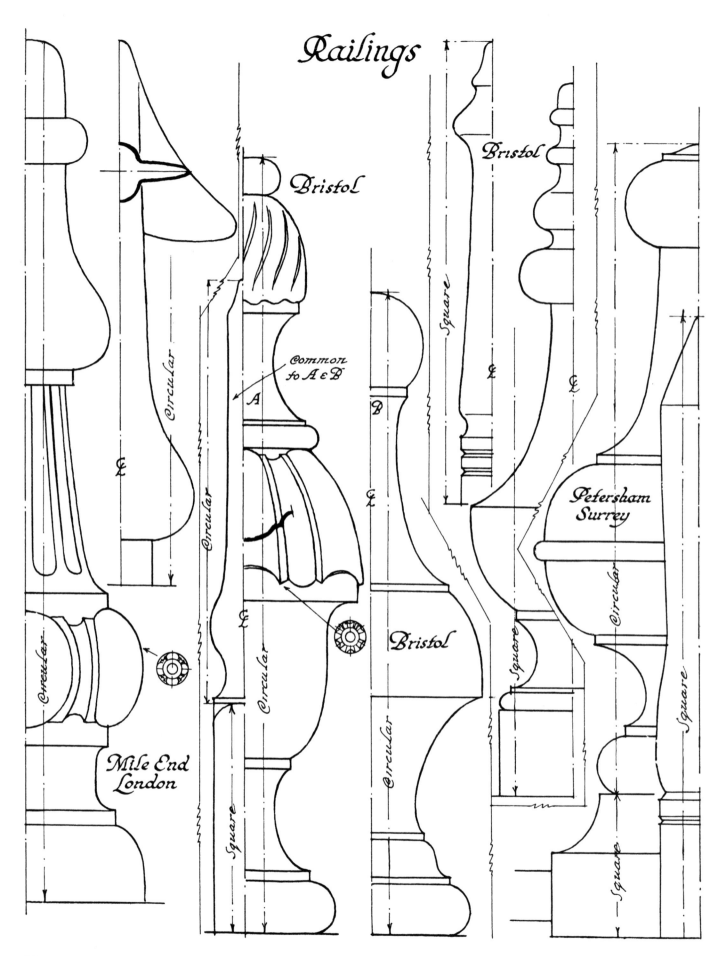

Railings

Bristol

Bristol

Common
to A & B

A

B

Circular

Circular

Square

Petersham
Surrey

Circular

Circular

Circular

Circular

Bristol

Square

Square

Mile End
London

Square

Square

32

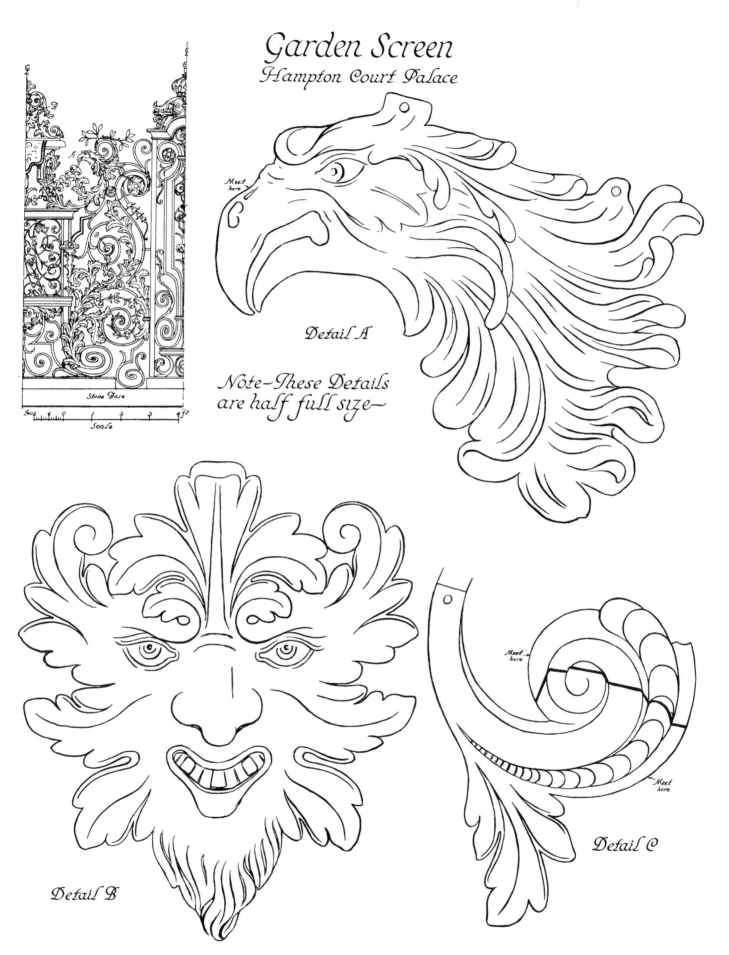

Garden Screen
Hampton Court Palace

Stone Base

Scale

Detail A

Note—These Details
are half full size~

Meet here

Detail B

Meet here

Meet here

Detail C

33

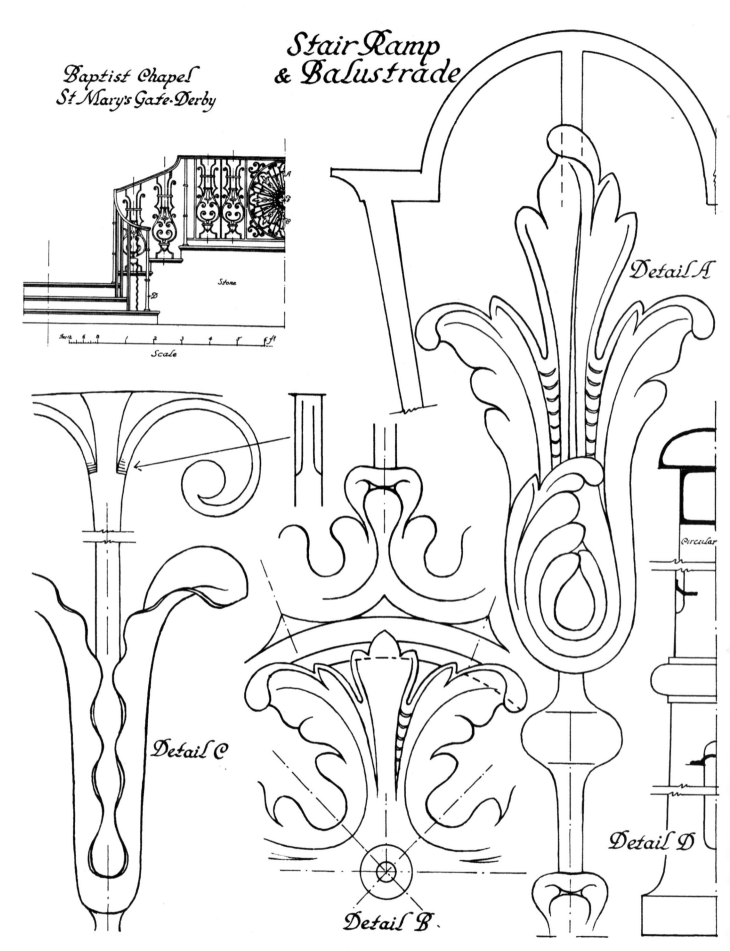

Baptist Chapel
St Mary's Gate·Derby

Stair Ramp
& Balustrade

Detail A

Scale

Store

Circular

Detail C

Detail B

Detail D

34

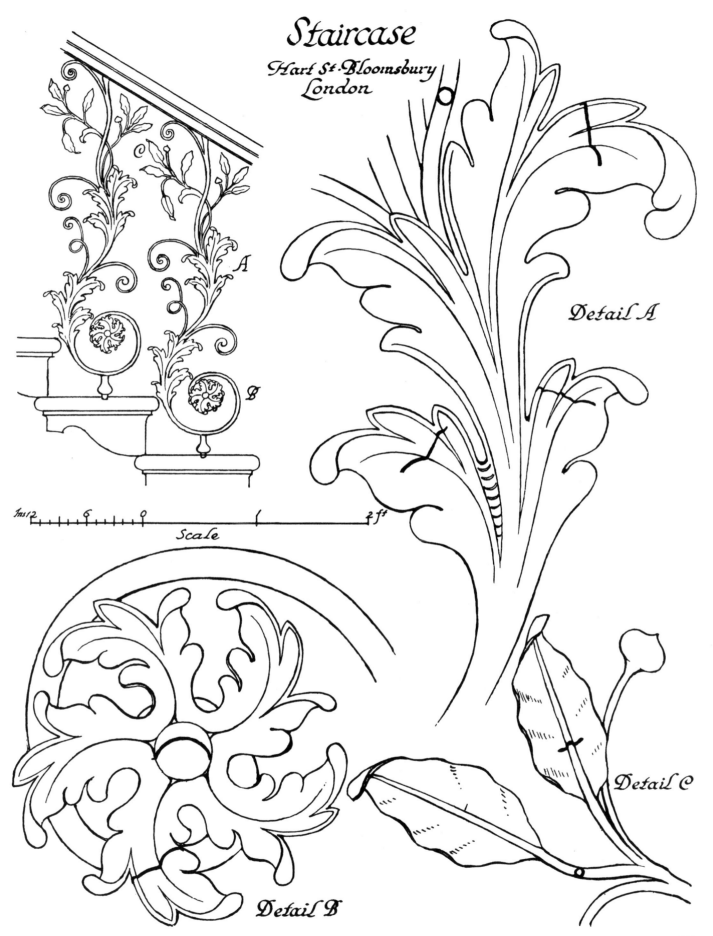

Staircase
Hart St. Bloomsbury
London

A
B

Ins12 6 0 2 ft
Scale

Detail A

Detail C

Detail B

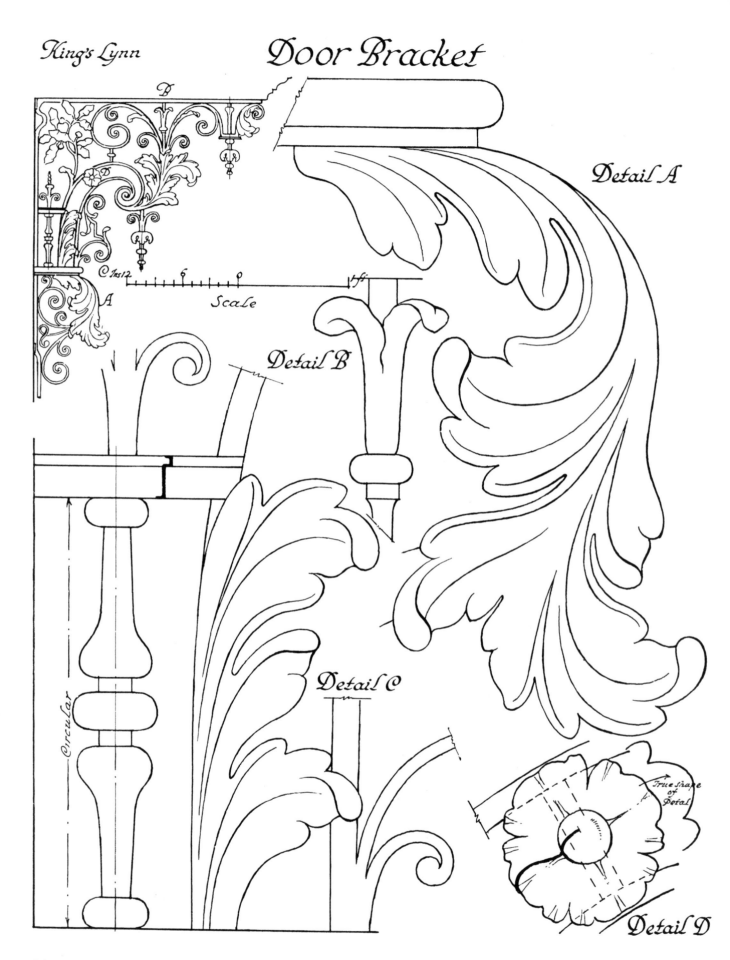

King's Lynn

Door Bracket

Detail A

Detail B

Detail C

Detail D

Circular

Scale

True shape of Petal

Scrolls & Bracket

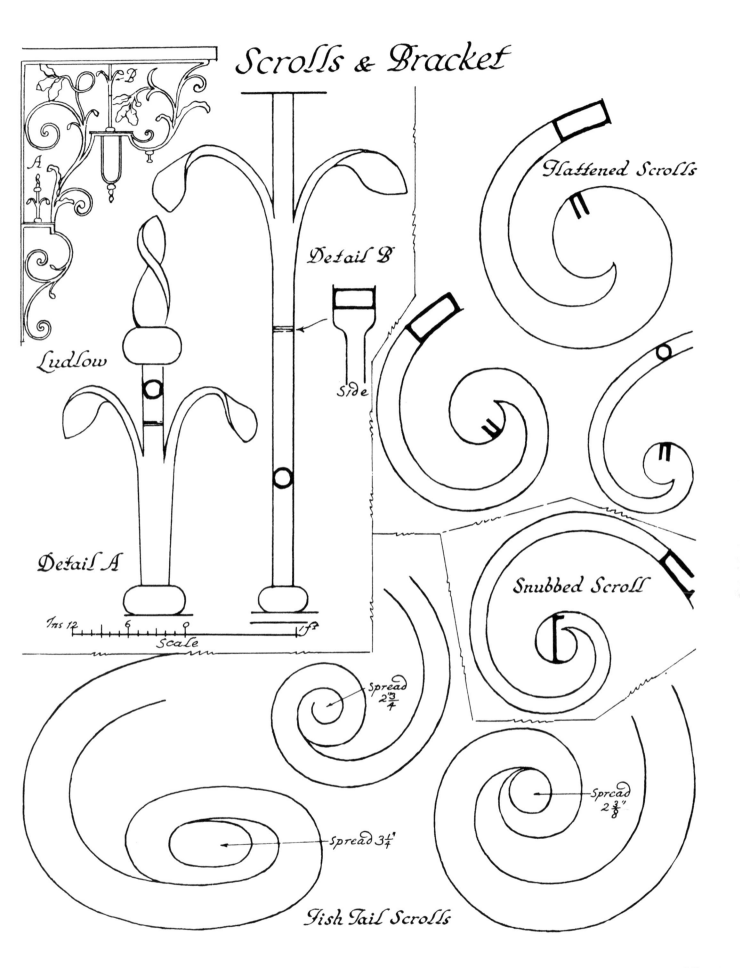

Detail B

Side

Flattened Scrolls

Ludlow

Detail A

Ins 12 6 0 1 ft
Scale

Snubbed Scroll

Spread 2¾"

Spread 2⅜"

Spread 3¼"

Fish Tail Scrolls

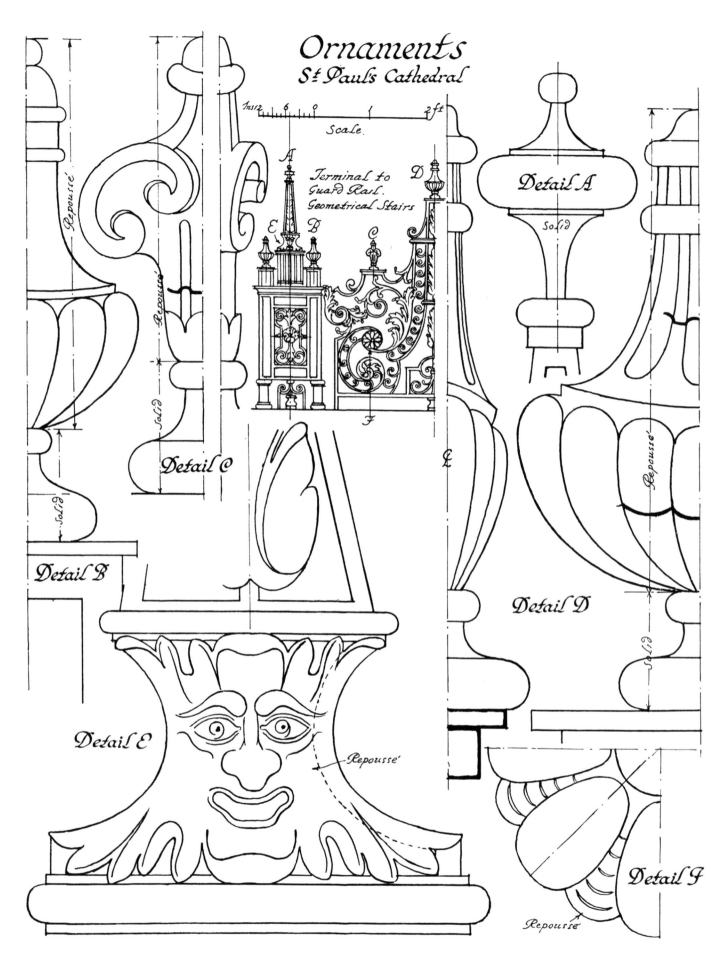

Ornaments
St Paul's Cathedral

Scale.

*Ins*12 6 9 1 2 ft

Terminal to
Guard Rail.
Geometrical Stairs

Detail A

Solid

Repoussé

Repoussé

Detail C

Solid

Solid

Detail B

Detail E

Repoussé

Repoussé

Detail D

Solid

Detail F

Repoussé

38

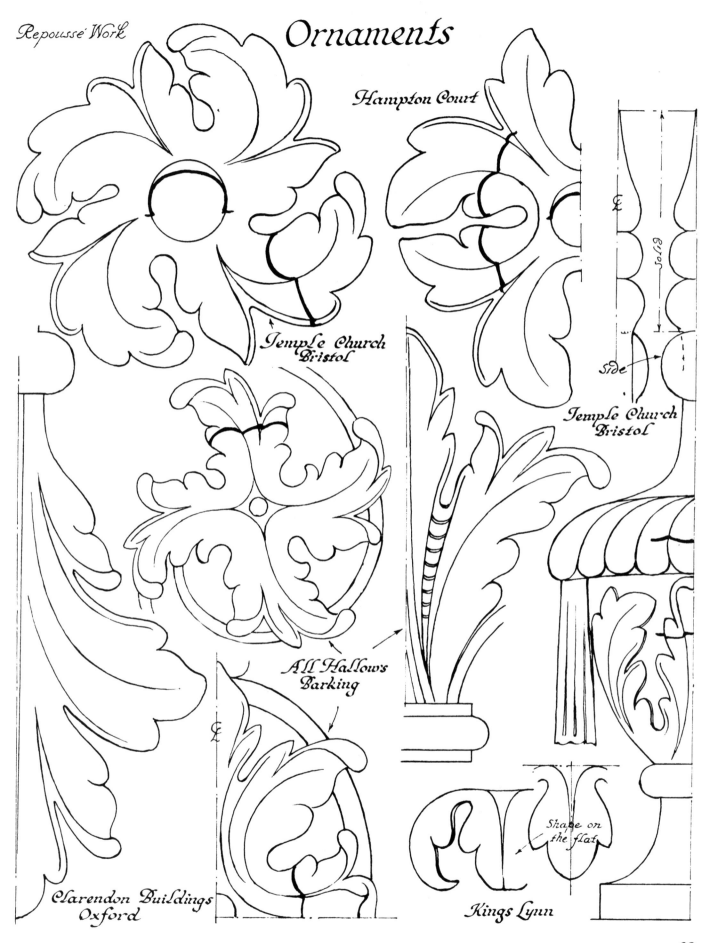

Hampton Court

Temple Church
Bristol

Temple Church
Bristol

side

All Hallows
Barking

Clarendon Buildings
Oxford

Kings Lynn

Shape on
the flat

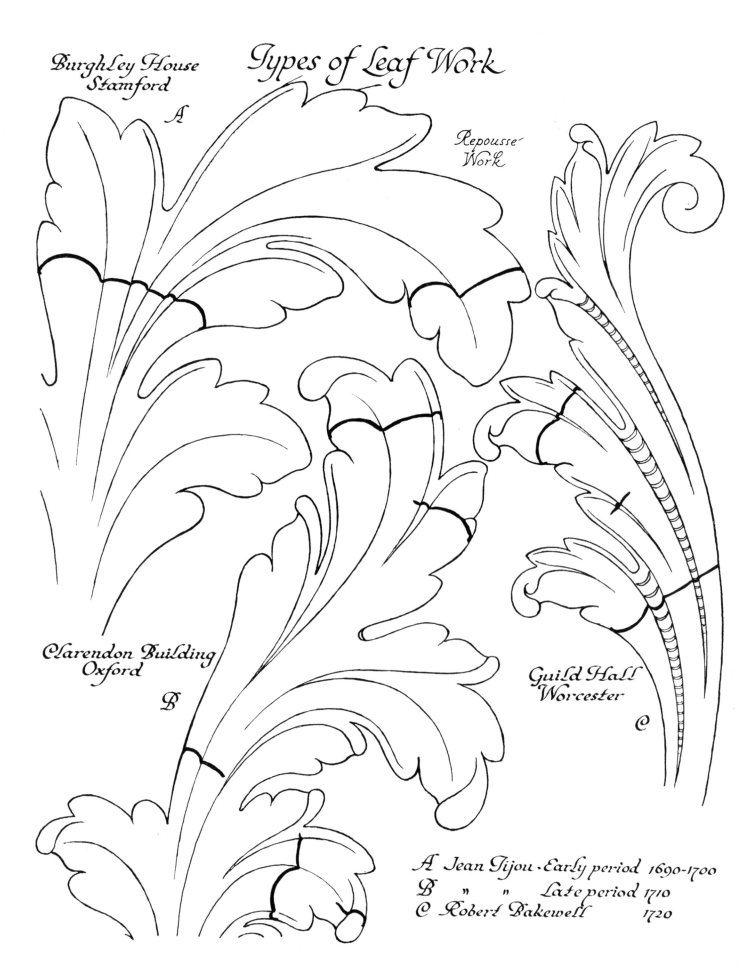

Types of Leaf Work

Burghley House
Stamford
A

Repoussé
Work

Clarendon Building
Oxford
B

Guild Hall
Worcester
C

A Jean Tijou · Early period 1690-1700
B " " Late period 1710
C Robert Bakewell 1720

40